NEXTDOOR IN COLONIALTOWN

RYAN RIVAS

autofocus books
Orlando, Florida

PRAISE FOR *NEXTDOOR IN COLONIALTOWN*

"In this brilliant and often humorous image-text assemblage, what emerges is an uncanny echo of specters and calls: for policing, firearms, and hot tub recommendations; to see "we are all humans with the same organs" and to watch out for some suspicious creature doing some kind of harm. Note the fragility, the shadows, the lawn objects, the white fright. In the afterword, Rivas offers a succinct account of suburbia as the continued legacy of white settler colonialism, including federal laws and initiatives which, taken up and taken advantage of at the local level, made it so. In other words, maybe the unsettling fact of Florida is that what happens here, happens across the United States."

— **TERESA CARMODY, AUTHOR OF** *THE RECONCEPTION OF MARIE*

"There is something to be said about people who lock themselves away in their 'nice communities,' desperately trying to separate themselves from 'worse ones.' Indeed, there's been much scholarship on white flight and its cousin, gentrification. *Nextdoor in Colonialtown*, however, lets those communities speak for themselves. And their words are deafening. Seemingly facile in its mission, this project is smart, bold and successful. You will never quite view your 'nice' neighbors the same. So, make sure to 'get your guns and ammo' ready!"

— **DR. CHESYA BURKE, AUTHOR OF** *LET'S PLAY WHITE*

"Ryan Rivas is a documentarian, a silent lurker in the evenly mowed grass of Colonialtown, a neighborhood as much haunted by its history as your own. What he chronicles is unnerving, amusing, endearing, repugnant, hilarious, and alarming; a stupid, grinning shadow of Americana, against which anyone would want to lock their doors and windows."

— **SARAH GERARD, AUTHOR OF** *TRUE LOVE*

"A disturbing and darkly funny aperture into the South, framing Floridian Suburbs as the new frontier and its people as living documents of its Colonial history and segregationist policies. Rivas' sometimes aloof, often satirical juxtaposition offers fluent commentary on the through-line between the "town watch" of Colonial America and the many "citizen observer" and vigilante organizations across the nation, where so many of us live out the racial drama as members of what Elizabeth Alexander has called 'the Trayvon generation.' Reminiscent of depopulated photographs by Bill Owens or Warren Kirk, the images of neighborhoods in *Nextdoor* appear staged, dewy, carried by buoyant palettes that bely the murky exchanges between neighbors. The text-image interactions deploy more recent conceptual fora harvest strategies like those used by Ara Shirinyan or Rob Fitterman to document the formation of collectives in online environments where, across the globe, hate and misinformation travel as absurd companions hurtling towards deadly assembly. In the suburban theatres of suspicion rendered in Rivas' haunting, sharp book, actors play out scripts of violent exclusion and virulent protectionism, directed by histories of racism and xenophobia to appear adjacent to each other while standing in opposition, gun or head cocked, in a surveilling intimacy that confuses a clenched fist for an extended hand."

— **DIVYA VICTOR, AUTHOR OF** *CURB* **AND** *KITH*

ISBN (Hardcover): 978-1-957392-07-3
Library of Congress Control Number: 2022937221

Published by Autofocus Books
PO Box 560002
Orlando, FL 32856
autofocuslit.com

NOTE TO THE READER

The images in this book were taken on a cameraphone in the Colonialtown North neighborhood of Orlando, FL. The text was assembled from Nextdoor.com posts and comments made by residents of Colonialtown North and surrounding neighborhoods. In each piece, individual "comments" appear as they did online, with some light editing for clarity. They form new "conversations" constructed from a combination of posts and comments taken from multiple threads.

Suburbia is both a planning type and a state
of mind based on imagery and symbolism.

— **KENNETH T. JACKSON** *CRABGRASS FRONTIER*

Race, in fact, now functions as a metaphor so necessary to the construction
of Americanness that it rivals the old pseudo-scientific and class-informed
racisms whose dynamics we are more used to deciphering.

— **TONI MORRISON** *PLAYING IN THE DARK: WHITENESS AND THE LITERARY IMAGINATION*

Time turns metaphors into things and stacks them up in cold rooms,
or places them in the celestial playgrounds of the suburbs.

— **ROBERT SMITHSON** *THE COLLECTED WRITINGS*

Colonization = "thingification."

— **AIMÉ CÉSAIRE** *DISCOURSE ON COLONIALISM*

I

COMMONSENSE • BOOM • BRICKS
A LESSON • HAPPIER • FLAG • FLIES
COYOTES (REASON)

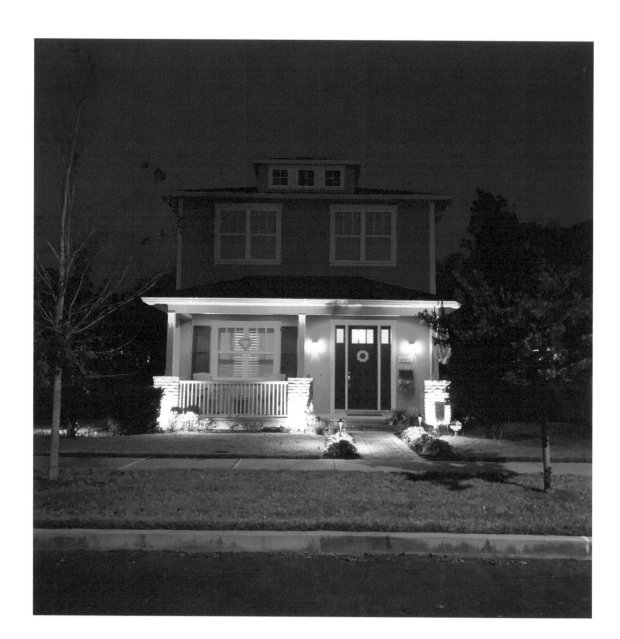

COMMONSENSE

— Just had a young man ring the doorbell and ask for a piece of bread. Strange! Caught on our camera if anyone needs footage.

— Description?

— Nice angular face but otherwise scary.

— Calling police/non-emergency probably isn't such a bad idea, especially since his behavior isn't exactly normal.

— I should have just went out and helped him, but I really didn't want to get dressed.

— This glitch in complacency will have a shelf life of five minutes.

— To be a good neighbor it is necessary to have a commodity that is in very short supply. Commonsense.

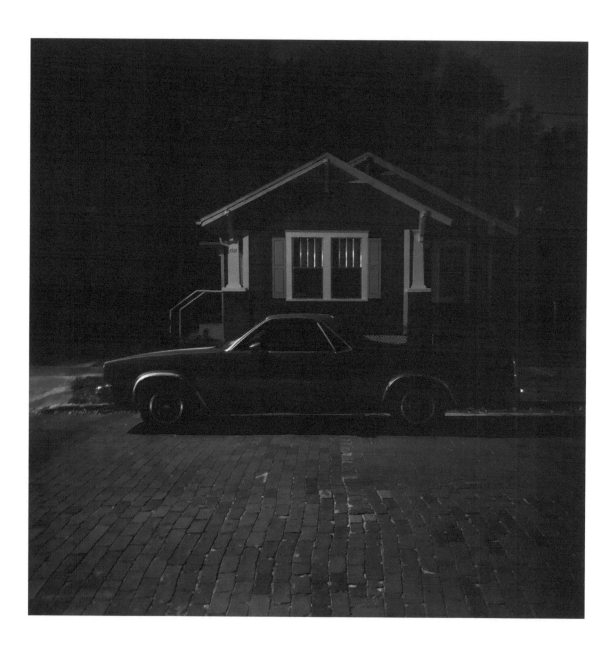

BOOM

— Did anyone hear that boom? What was it?

— Yes, what happened? I haven't heard a thing.

— Anyone know what's going on? Helicopter is circling around Colonialtown North over and over.

— This is not good... They are still over our heads... Circling another five times...

— The nicest communities are a short drive from the worst.

— It's the stupid exhaust on these cars. It's made to sound like gunshots.

— Lock up. They're still hovering.

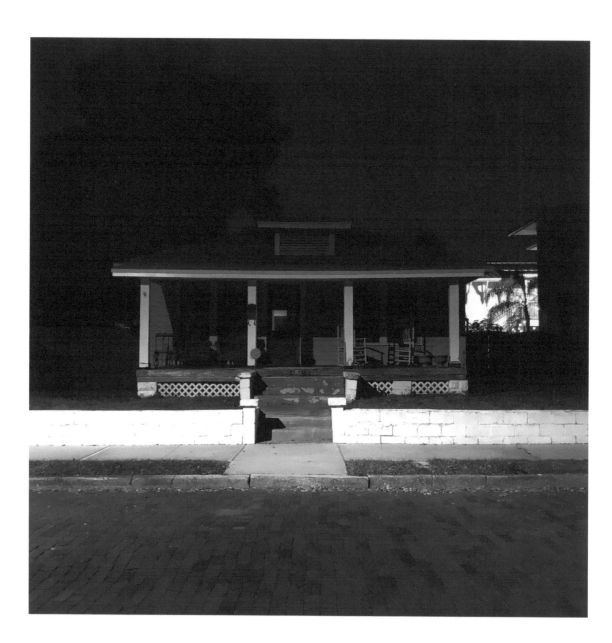

BRICKS

— A man comes by and takes a brick from my yard. I knock on the window. He sees me and takes it anyway. I don't know how you get the street fixed but I was saving them for that occasion. White hair and mustached. Looks like a short haired small Santa. Nice small truck. I guess he's collecting bricks to repair his street or build an historic grill. That was my brick. Thief. Looked straight at me and took the brick. Keep an eye on your bricks.

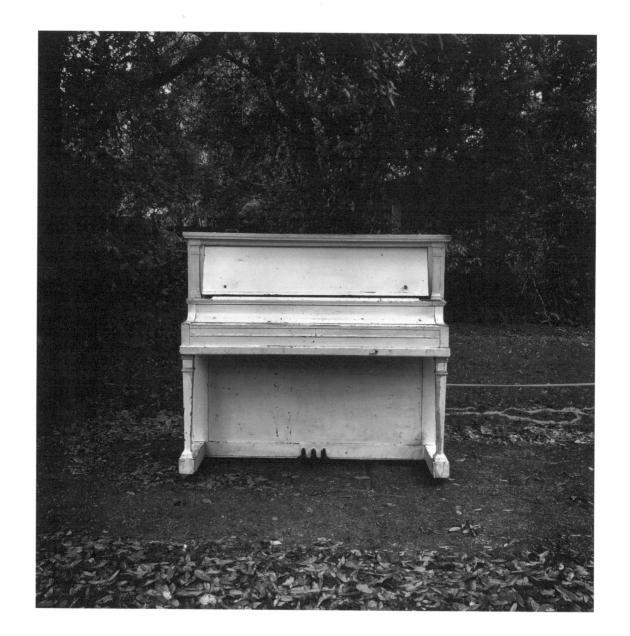

A LESSON

— Called 911 for a noise complaint at 11:20 p.m. and it was normal level by 11:40 p.m.

— I just want to know what it is that motivated you to lodge this complaint. Thanks for making things just a little more harder for me.

— If you wanna play, be prepared to pay. I grew up knowing there were consequences for every bad action. Not enough kids are taught that today.

— Please find out who reported you. Then find lawful ways to make them miserable. I mean go out of your way to give them other things to worry about. I know it sounds petty, but it's really the only way to teach these people a lesson.

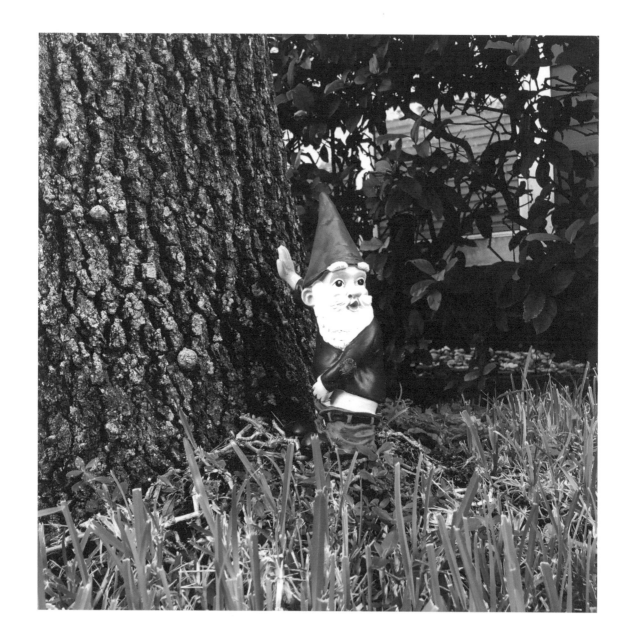

HAPPIER

— We don't need any more bad people in our country.

— The real reality of life is that this world is full of good people and bad people.

— The ones that are good are really good. The ones that are bad are really bad.

— So sad that some people are just such bad people.

— There is NO bad race, just bad people.

— I was much happier when I didn't know what kind of people lived in our community.

— I'd gladly trade some of my non-awesome neighbors for plants.

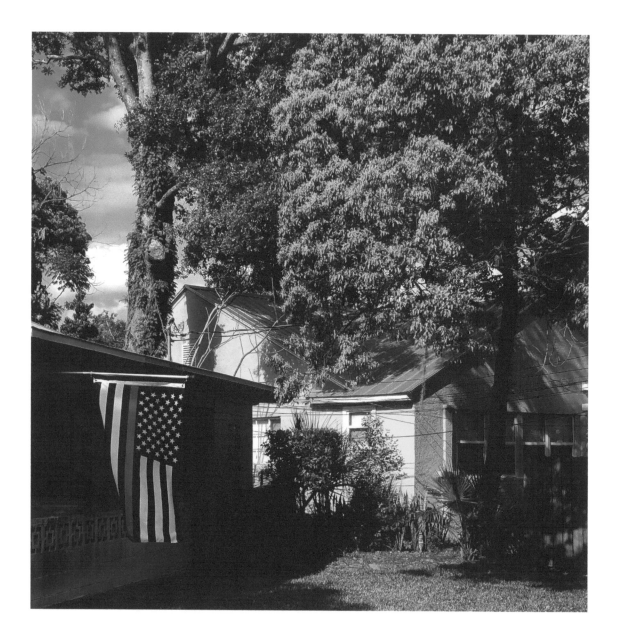

FLAG

— Well, the Marks Street arsonist has struck again. Kinda. The last time the Marks Street arsonist was here, the flag on my house was set afire. In the daytime. This time, however, the flag attached to my house was stolen off of the flagpole under cover of darkness. Thieves and arsonists, oh my. Lucky me. Domestic terrorists come in many guises.

— Did the dark man have on an American flag mask?!!

— I talked to him through the window glass. The talk was strange. A quiet rant.

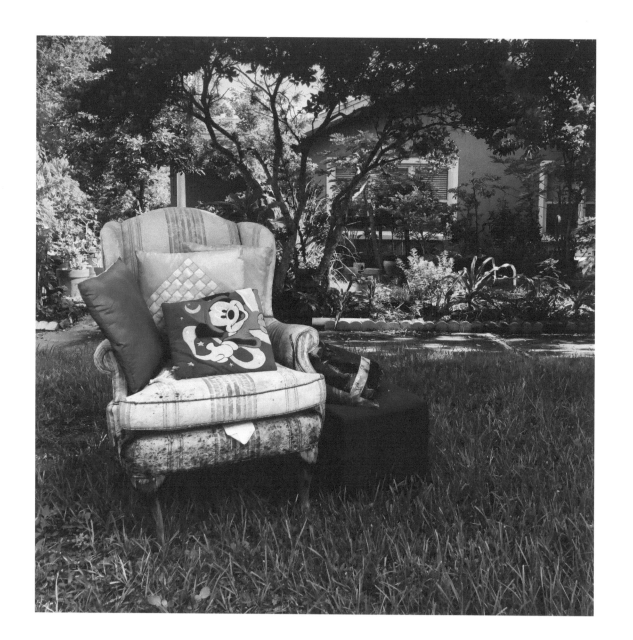

FLIES

— I am dealing with more and more flies.

— I seem to remember these being discussed recently. Was it ever determined what they mean?

— The developer has been trying to intimidate some of the neighbors.

— It sucks, but it's economics… nothing personal. The best thing to do after trying to negotiate is to move, unfortunately.

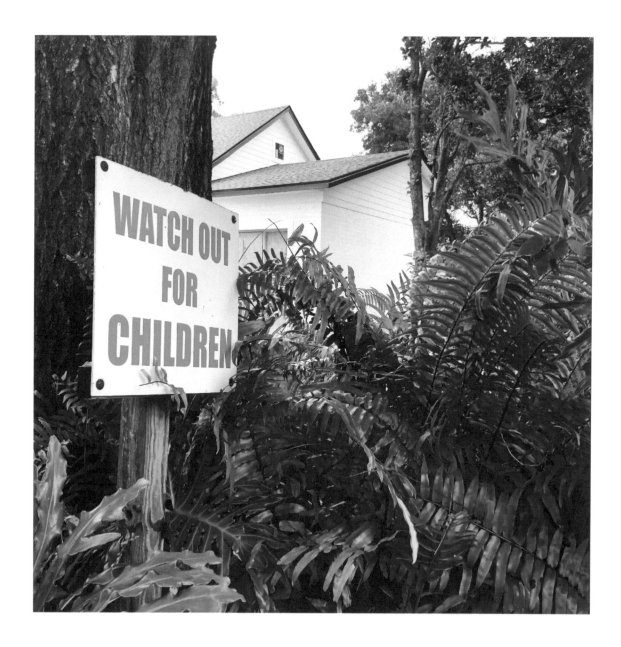

COYOTES (REASON)

— Coyotes spotted in Colonialtown.

— Some people were using their non-native status as further reason to eliminate them. It isn't ample reason.

— They're now listed as Naturalized.

— They're invasive.

— We cannot let small dogs be virtual prisoners while letting the gangster coyotes run the show.

— They are fast-moving, pack-hunting superpredators.

— They should be hauled down to the pound just like every other delinquent. What's good for urban domesticated is good for urban invaders.

— Do you not have a conscience?

— It was just a metaphor.

II

DINNER • VICTIM • MORALE
NATURALLY • DISCORD • AREA • IDEAS
SOMETHING • COYOTES (SOLUTIONS)

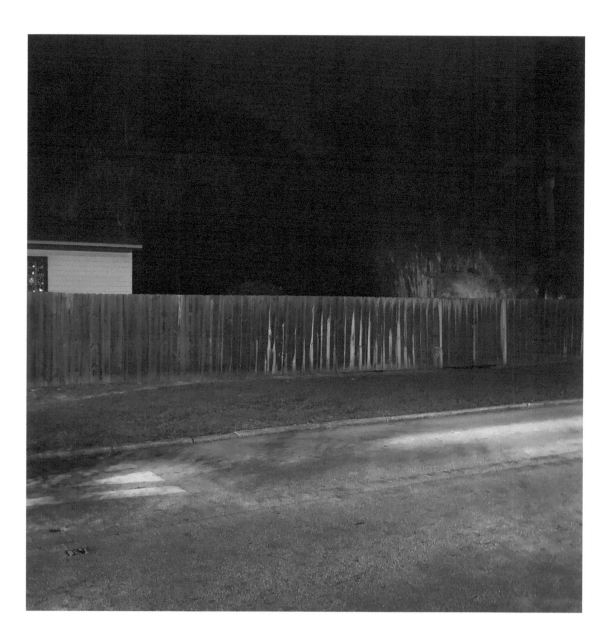

DINNER

— This evening a strange man rang my doorbell telling me he was at my house for dinner. I've never seen this man before in my life and don't know him. When I inquired further he said "I heard you were cooking dinner."

— Did you call the police???

— Ringing the doorbell isn't a crime, so no.

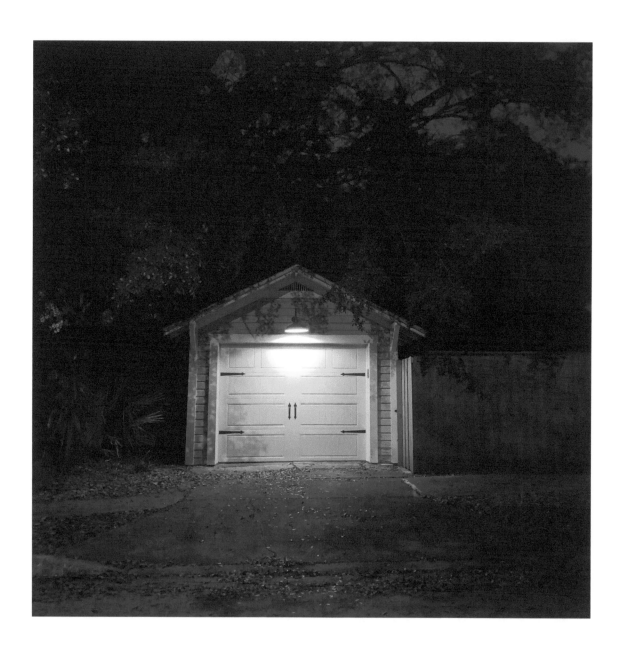

VICTIM

— I'm very paranoid about my garage door. Coming in and going out of my garage is a high security maneuver.

— A little prudent paranoia is better than being the next victim.

— Might be worth calling in to law enforcement.

— I only count on myself to protect me.

— You're being a bit presumptuous for someone being victimized.

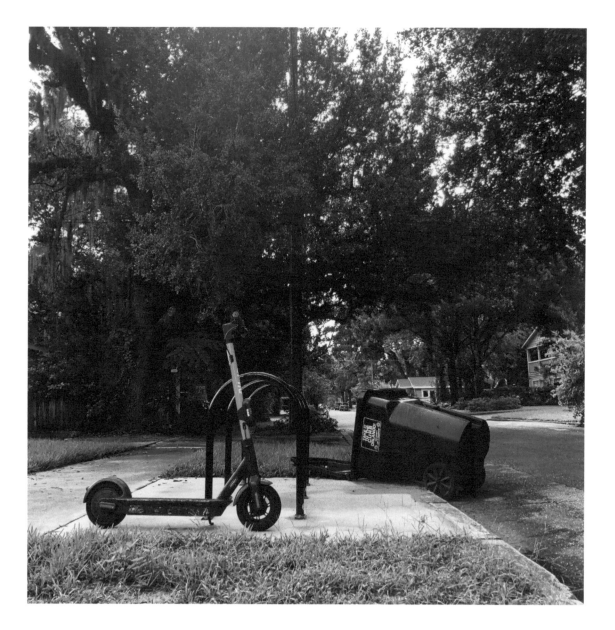

MORALE

— A thief has charged over six-hundred dollars in scooter fees and McDonald's to our account within forty-eight hours. Apparently this person likes to rip and ride around on one of those rental scooters, and in between stealing from his or her victims they like to occasionally stop at McDonald's for a feast.

— Overcompensating for something.

— WHERE ARE THE POLICE????

— Please don't blame the police, social justice warriors have made it impossible for them to do their jobs anymore. Morale is in the toilet.

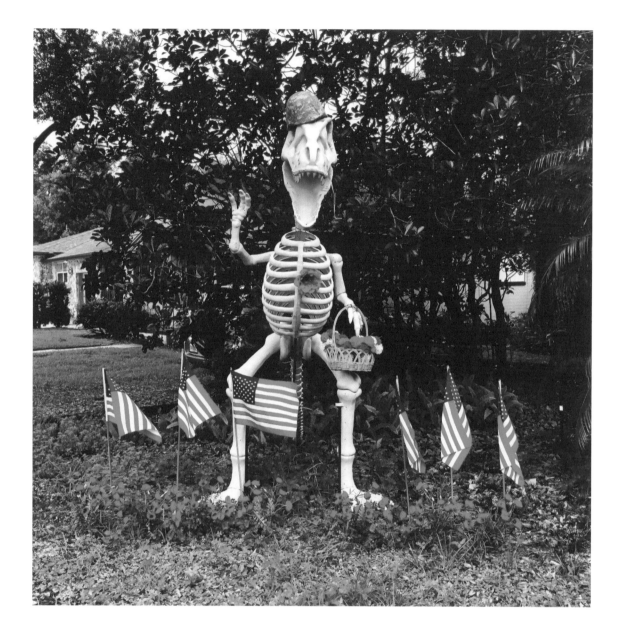

NATURALLY

— Please be aware of golf carts within your community. Florida State Statute allows drivers to be at least fourteen years of age or older when operating a golf cart on a public road or street.

— It's going to be a free-for-all in a lot of places soon... get your guns and ammo while you can!

— These are children for crying out loud.

— Well, I just mentioned it naturally without any bad thoughts at all.

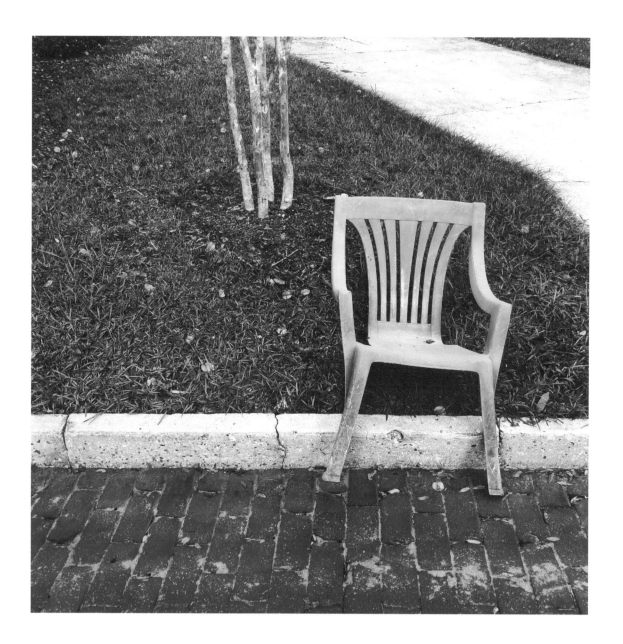

DISCORD

— I found a free "newspaper" in my driveway yesterday. Something seemed wrong as I looked through it. Some good information but it was all very biased. And very "white." Out of one hundred and eighty photos only four had a black person visible.

— Is it some type of weapon?

— I don't think there should be any separations. It causes discord. We are all humans and those who want to separate us into groups are desirous of policies that fly in the face of the constitution as well as Dr. MLK and any other person who ever fought against racism or segregation.

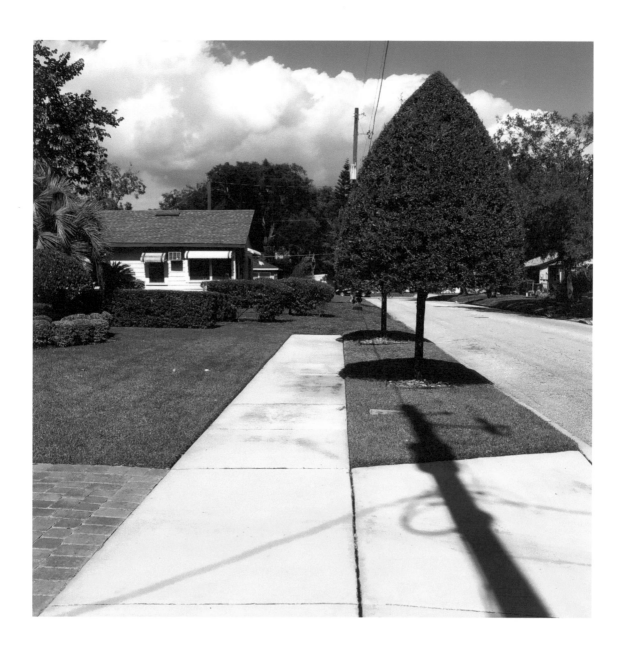

AREA

— Anyone know a place close by where I can get into a hot tub? Willing to drive twenty-ish minutes or so to get there. I am just having a mega hot tub craving right now.

— We're all blue collar over here.

— Yes. It's at the dead end leading to the lake.

— What is it with people coming to our nice area and doing these things?

— I'm installing cameras this weekend.

— Very important for us all to help each other with overlapping cameras.

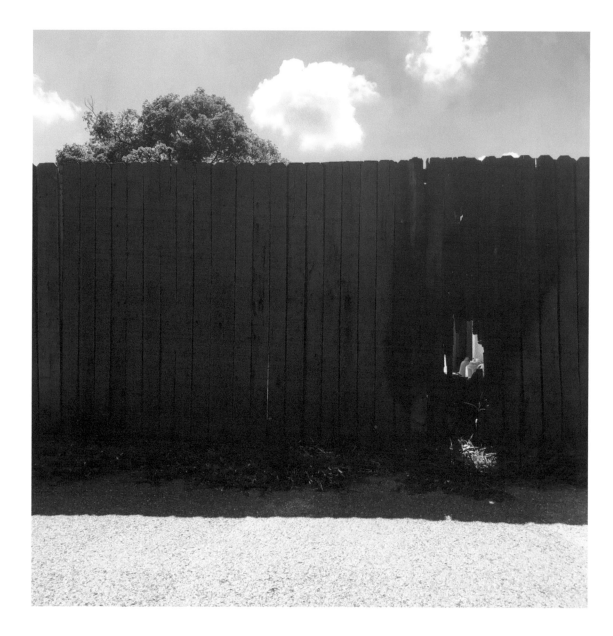

IDEAS

— Call me crazy but I think it is time for more to be done to control the crime and vandalism that is destroying our city. Any ideas on what can be done?

— I sit out a lot in my little area and keep an eye out while enjoying the night. Anything I see suspicious and wrong, I'll call the police.

— I started a "Neighborhood Watch" but hardly anyone showed up. I was threatened for putting out the flyers.

— Catch them and throw away the key.

— It's all in God's hands. There is no sense in arguing your beliefs. Arguing is non productive and unhealthy. Live life to the fullest and enjoy each others' company.

— Or simply choose not to live in fear.

— Individuals continue to wait for someone else to take action.

— Deputize yourselves and go forth!

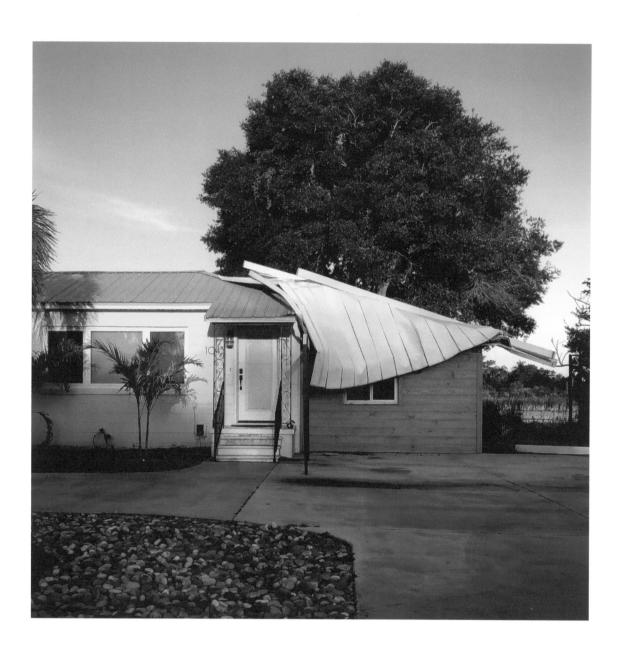

SOMETHING

— I saw something that did not happen.

— Maybe that's why residents are calling each other crazy.

— You can visit my home and see my intentions are pure.

— Cops should have been called to investigate.

— If I could do it over again then I would definitely have called the police.

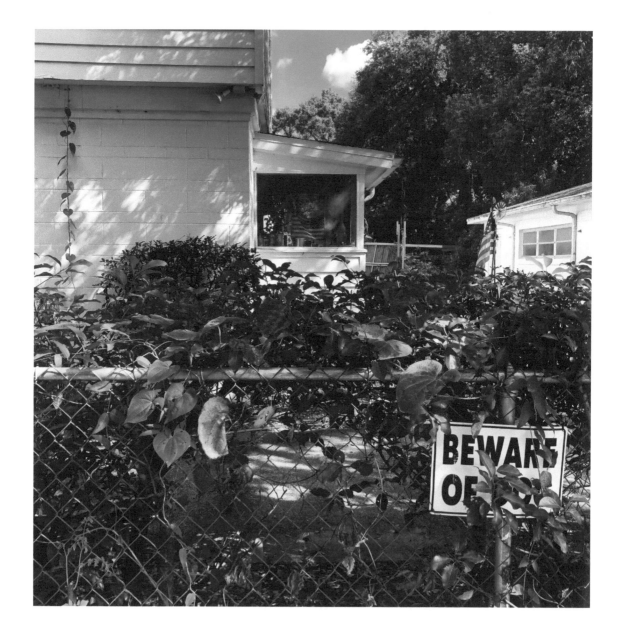

COYOTES (SOLUTIONS)

— Coyote meeting in progress.

— I've been listening on the police scanner.

— We are working on active solutions with the coyotes.

— Do not become friends with the coyotes.

— A death mission.

— We manage them, protect them, and put them in their proper place.

— The pack has grown and has clearly lost its fear of humans.

— Humans create our own problems and then blame the "monster" animal for the devastation caused.

— Lock your house, lock your car, lock your bike, close your fence gate.

— When locking your car doors always hit the lock button multiple times.

III

BABY CLOTHES • BODIES
DESCRIPTION • GUEST • PLANT
MOTIVES • HOME • COYOTES (HUMANS)

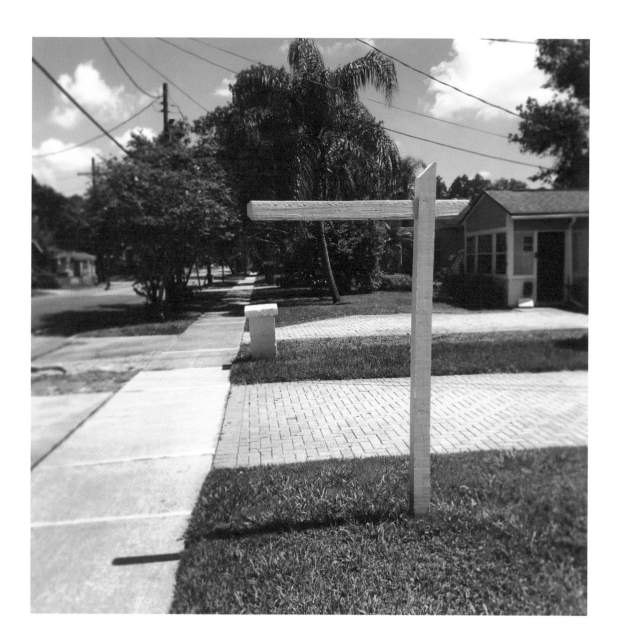

BABY CLOTHES

— Someone has left baby clothes in front of my door and I have absolutely no idea why.

— Did you report to police?

— How many firearms have you purchased?

— She actually has an A.R.

— What does A.R. stand for?

— I'd call the cops… or is that offensive?

— Only if you feel threatened. That's how P.O.C. get roughed up or shot.

— P.O.C.?

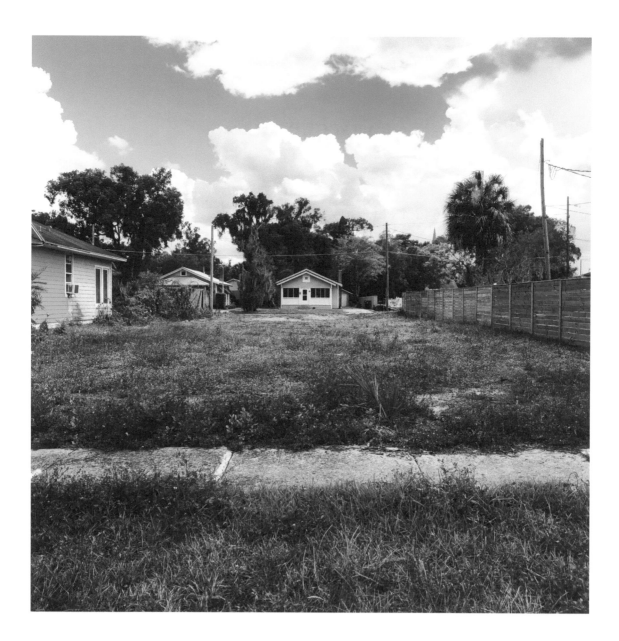

BODIES

— The body was in a white sheet in the tall grass.

— A human body?

— What about the body last night?

— Another body on Sunday? Where?

— A "vibrant" community (real estate term for high crime).

— This seems to be where the bad stuff happens (including the body picked up the other week).

— I haven't seen that anyone has been able to determine the meaning behind these.

— It means that bodies are piling up due to mysterious (probably sinister) causes.

— I think everyone needs to stop taking everything so literal.

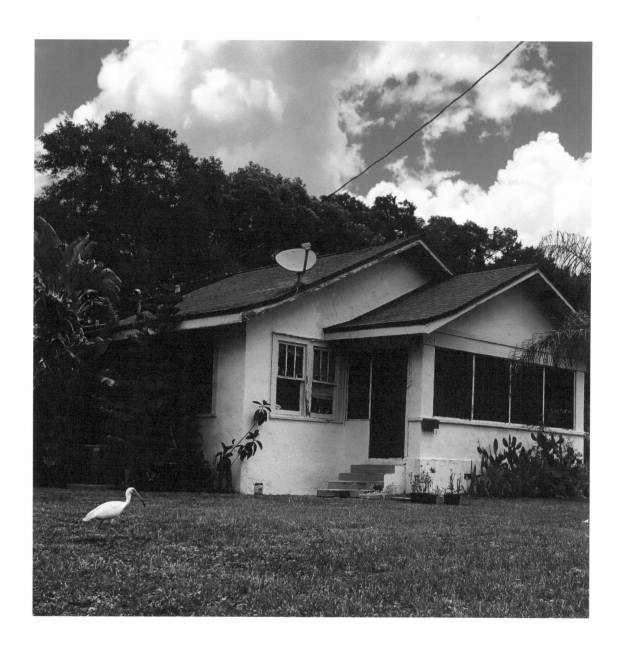

DESCRIPTION

— Be very careful. My former neighbors just alarmed me with news of someone intentionally poisoning the neighborhood cats.

— Can you describe him?

— Looks like an "egg" enclosed in white.

— A penguin? Doesn't appear human.

— An unidentified individual dropping unidentified substance onto cat food and surrounding sidewalks and grass.

— Can he not work, and if not, why not? Is he just lazy? Who knows? We need details.

— Police are saying it's a male juvenile they are looking for.

—THE MAN'S DESCRIPTION SOUNDS LIKE AFRICAN AMERICAN BUT NOBODY CAN ASSURE IT.

— We are all humans with the same organs and just different types of colors on our skin.

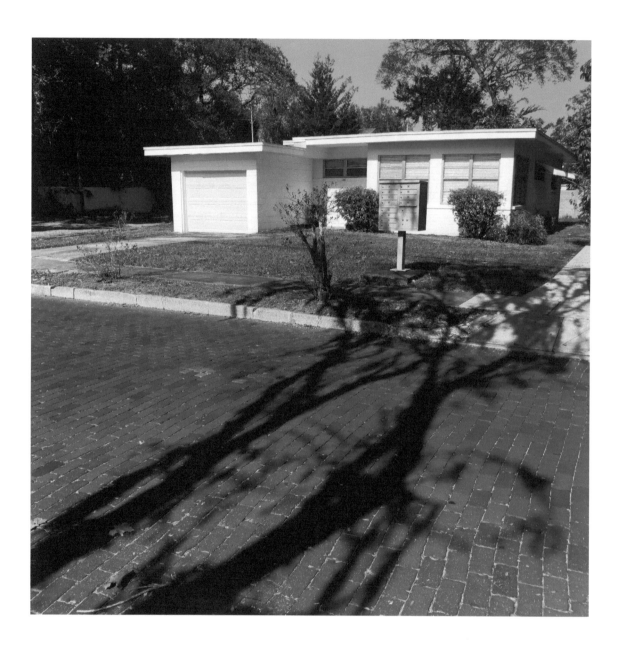

GUEST

— I received a letter stating that "my cat" is an "unwelcome guest on a private property." Interesting enough, I don't have a cat.

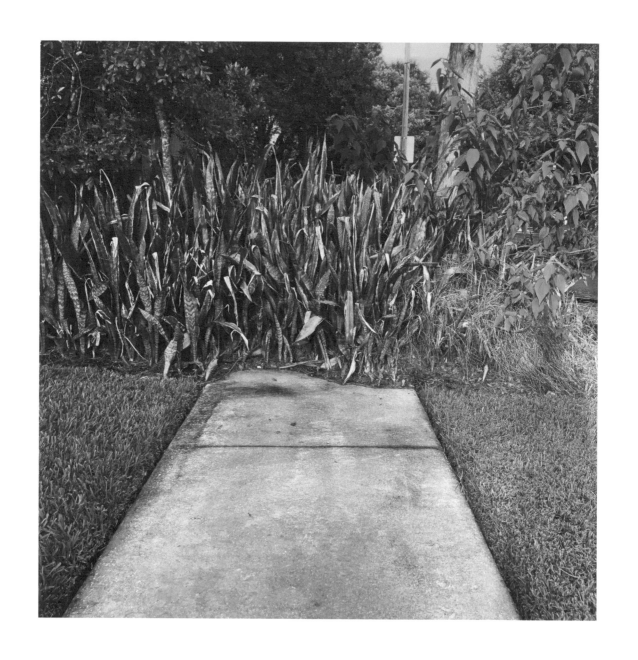

PLANT

— While away on a weekend trip, presumably the world's most evil person stole our fiddle leaf fig plant off of our porch.

— Thank God nothing happened to you. Evil people don't look like monsters.

— So glad you're safe. Please arm yourself.

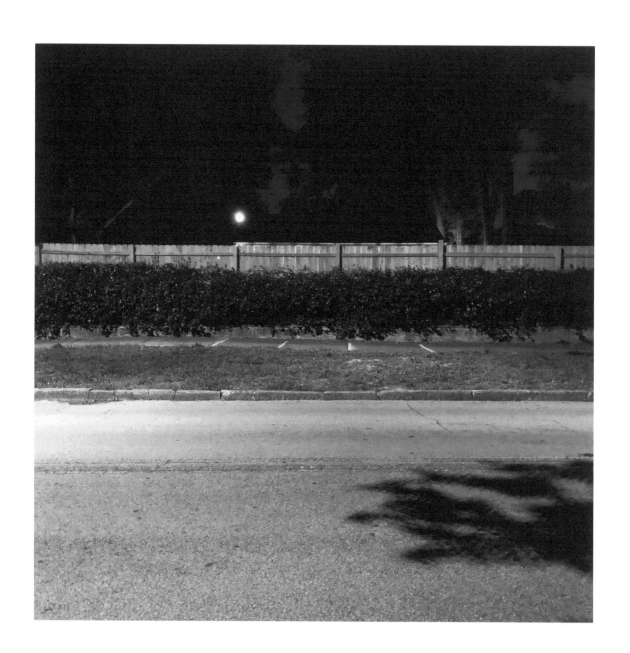

MOTIVES

— Where are the night patrol police? Seems like there are none. People should talk to their area representatives and demand better police patrol overnight. I remember a time, just a few years ago, when a person couldn't take a late night walk without police stopping to question their motives and ask for ID. Apparently none of that is going on anymore.

— Crime prevention is everyone's responsibility.

— We can trace crime and not following rules for safety to the story of the forbidden fruit.

— Yep, the Amish understand that concept as well as anyone and they go about their business without incident.

— The police cannot be there to protect you, but they can exact revenge after the crime.

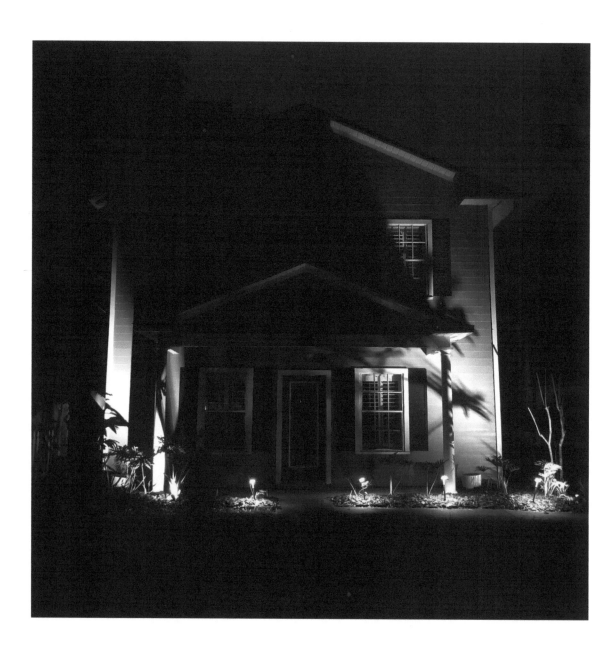

HOME

— A stranger in anyone's home is a potential threat and should be treated as such.

— Even most people living in homes are not safe to be around.

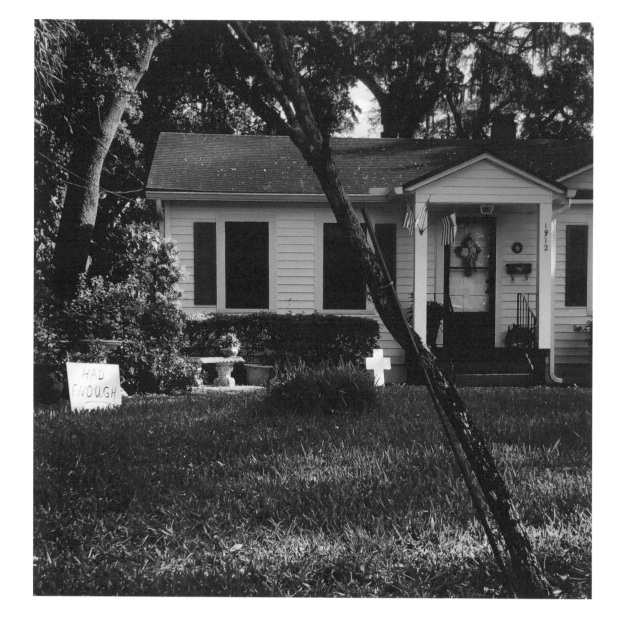

COYOTES (HUMANS)

— Just after 9 a.m. this morning, a (black) coyote ran down Glenwood. It charged full speed at me and my dog. I was able to quickly pick my dog up. I squared off with the coyote, staring it down. It then curved around us and ran again at full speed toward Bumby.

— Coyotes are roaming our neighborhood nightly!

— They run a very particular way. Keep in mind it's mating season, so you may see more out and about.

— The "service dog in training" vest is a hoax.

— Were you able to get a shot off?

— What is with you humans killing everything around you?

IV

PROBLEMS • LAWN • RESCUE • REALITY
CHANGE • THOUGHTS • VANISH • LOCATE
COYOTES (ENCOUNTER)

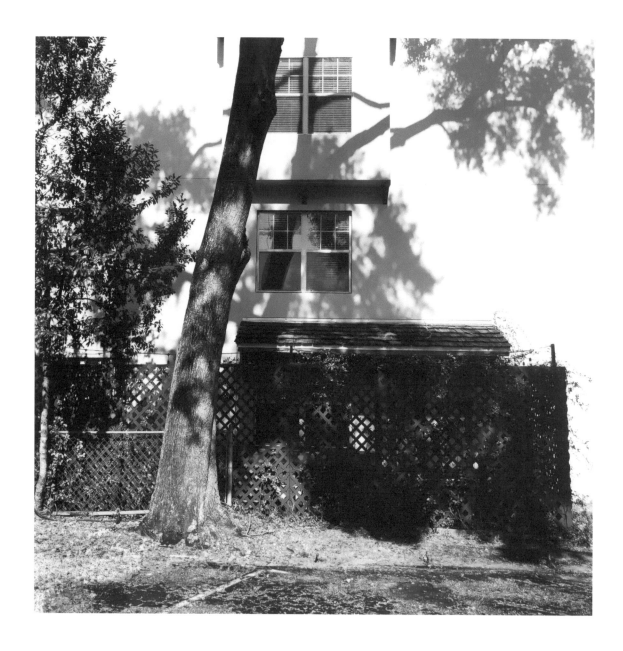

PROBLEMS

— Within the last hour, a bunch of bees have gathered near my front door. I have no clue what to do.

— Stop answering the door, but watch them carefully.

— Our house has had no problems since we put bars on our doors and windows. It's not the prettiest but we've had no problems for over twenty-five years.

— Too much anxiety will not help. Maybe take a break from worrying about it?

— Learn to live with them and keep your small pets safe.

— Listen to the advice... get a gun.

— The life you save may be your own!

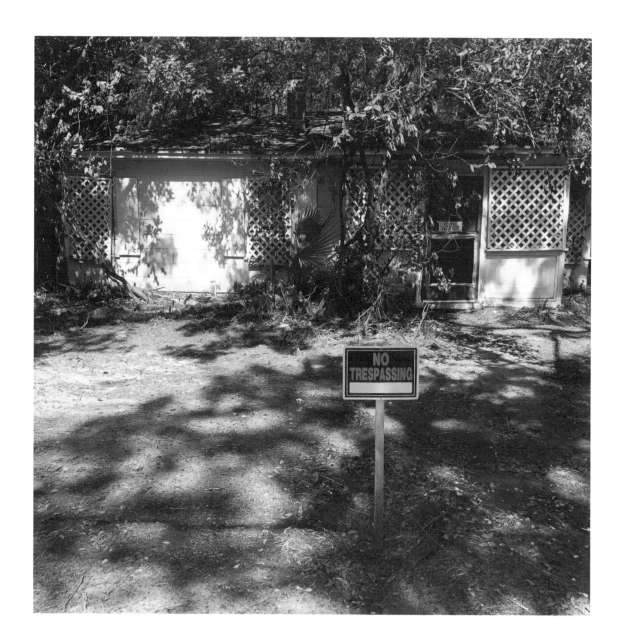

LAWN

— My lawn is dead!

— It wasn't one of us who caused this horror.

— Please remember to secure your property.

— We don't have a fence.

— Make sure it's fenced across the top as well.

— Nor do we have a moat.

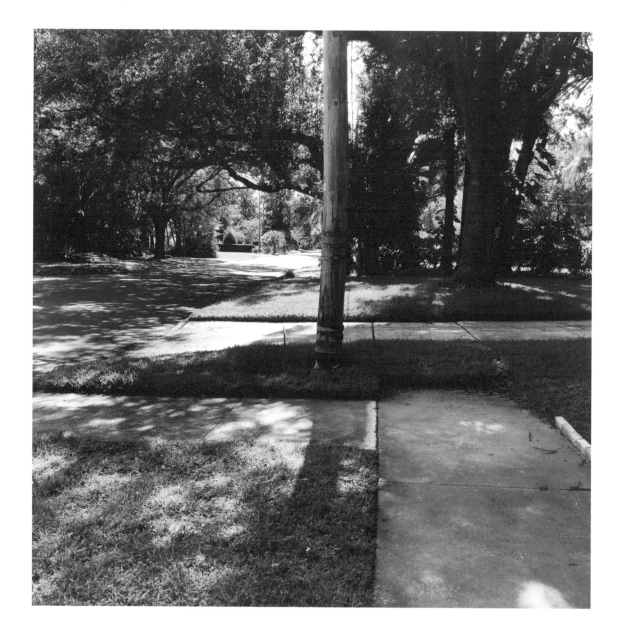

RESCUE

— I normally would not use or endorse a person like Frederick. However I heard his story and felt compelled to give him a chance. Frederick knocked on my door with a smile and I gave him some work washing my car. He did an excellent job, as I'd planned to run the car through the car wash anyway. He hadn't eaten so I gave him some water, an apple, and trail mix. Frederick was very grateful.

— As many of you may know we lost our rescue Fred this past summer, which we still find very suspicious.

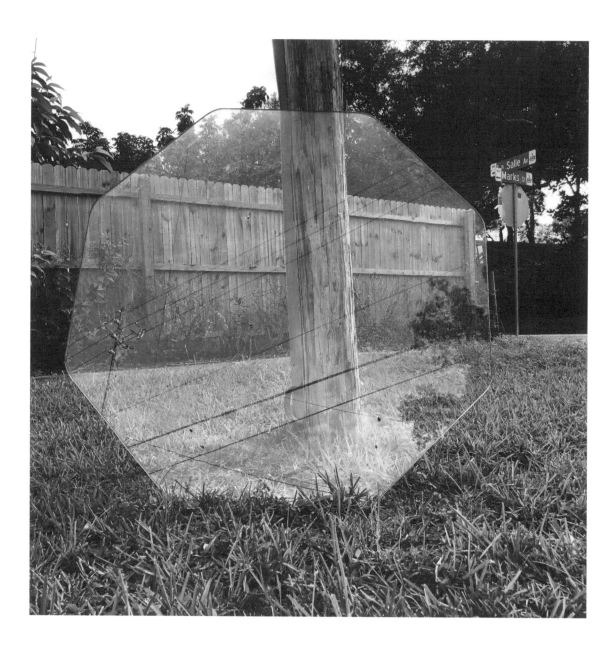

REALITY

— I have a statue in my kitchen now.

— Someone I know had this happen to them yesterday, and sure enough there was dead rats in their attic.

— Talk about an unexpected side effect!

— Does anyone know what it means?

— I'm not exactly sure myself, but artists communicate through their work and this person seems to have a lot to say.

— We're living in a different time and world now.

— I pray she survives this new reality.

— A bit weird, but I could get used to it.

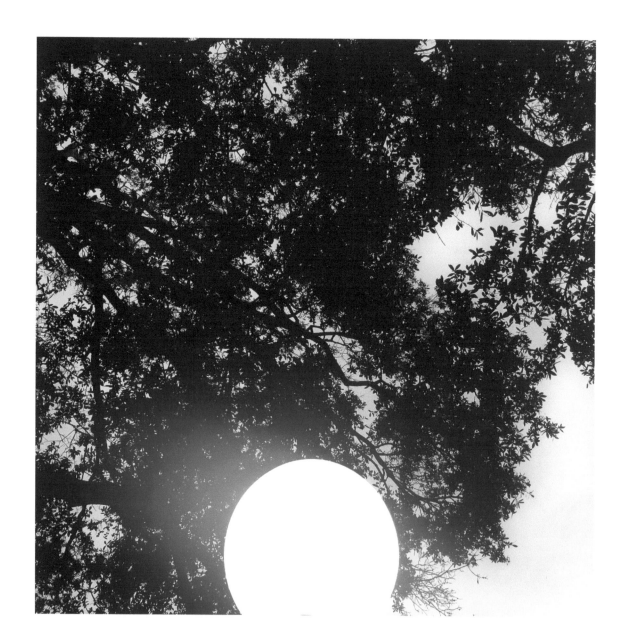

CHANGE

— Has anyone else noticed where all the squirrels have gone, or what happened to them? There have been squirrels here forever, but they've completely vanished.

— A timely reminder of how quickly things can change.

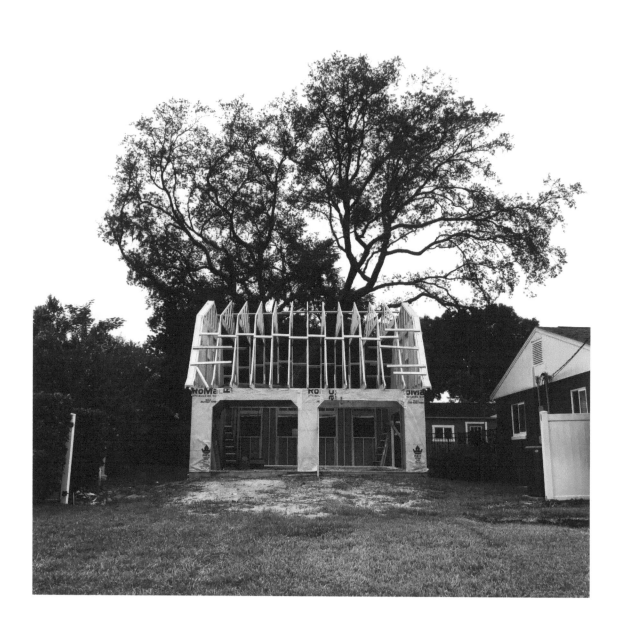

THOUGHTS

— I just heard around ten or so gunshots (or what I thought were gunshots).

— I thought I heard another one today. I thought I was hearing things.

— We do not have anything attributing our thoughts to anything other than the brain in our head.

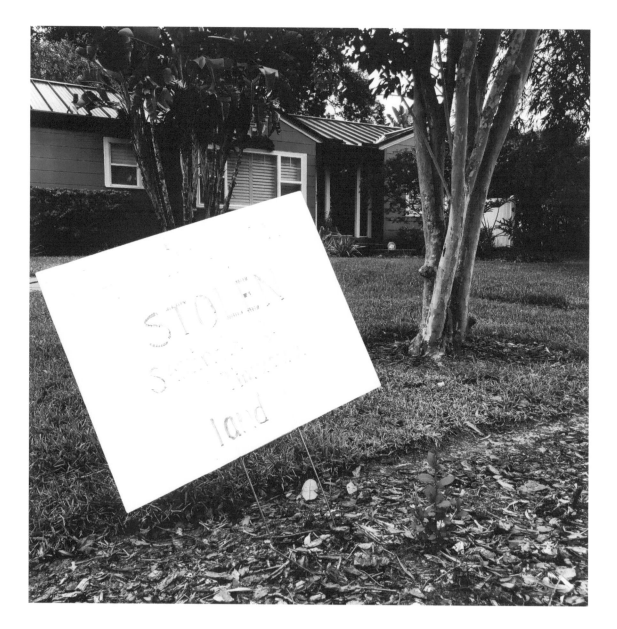

VANISH

— We are becoming a nation of thugs and brutes who think they can do anything they want so how do we stop them??

— Every morning, take your shoes off and stand in the grass to ground yourself. Say good morning to those you oppose, for the next sunshine may never shine.

— Are we pointing the finger at everyone else, but not at the person in the mirror?

— Close your eyes and all problems vanish.

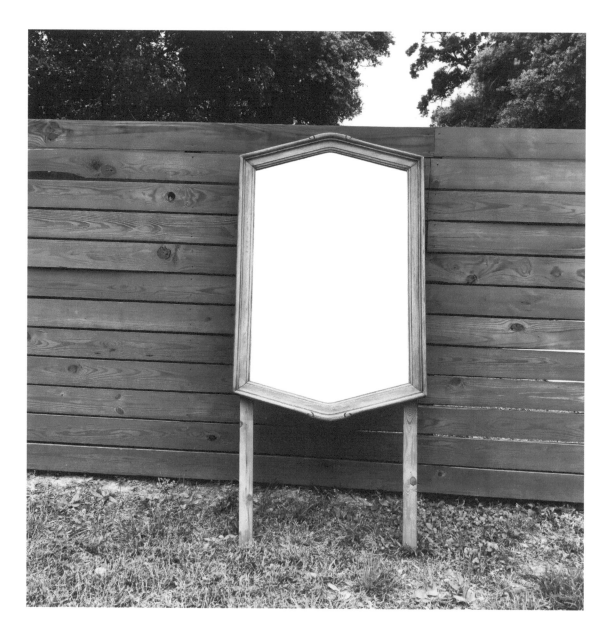

LOCATE

— Can you help us find out where the neighborhood went?

— I would be willing to help locate our neighborhood.

— You can't stop looking, even if you want to.

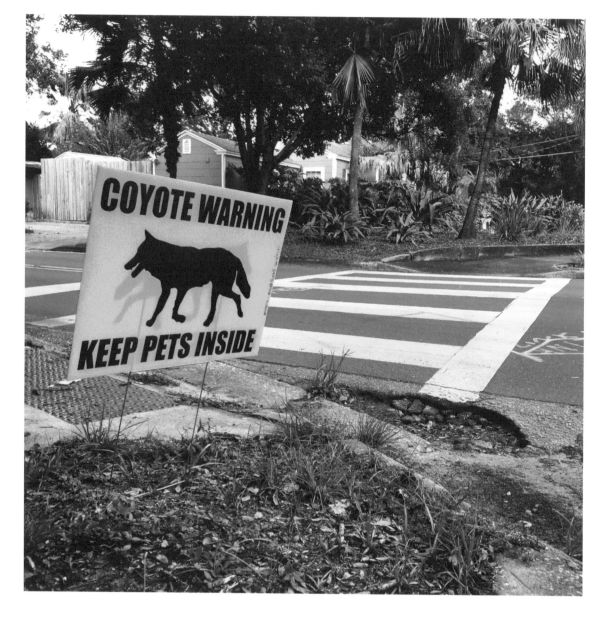

COYOTES (ENCOUNTER)

— Here are things to do if you encounter a coyote: If you're walking a smaller dog, pick it up. For larger dogs, pull them in close to you. Make yourself appear the bigger threat. Stand tall, stare into the eyes of the coyote and shout at it. You also can throw something at it. Do not run or turn your back. Running may change the coyote's opinion of you from aggressor to prey. Continue to "haze" the coyote until it leaves the area; then you should go, too.

FOR ALTERNATIVES TO CALLING THE POLICE IN YOUR COMMUNITY
VISIT **DONTCALLTHEPOLICE.COM**

FOR RESOURCES ABOUT TRANSFORMATIVE JUSTICE AND MORE
VISIT **TRANSFORMHARM.ORG**

A NOTE ON THE ORIGINS OF SUBURBAN ORLANDO

The city that would become Orlando was first established near Fort Gatlin during the Second Seminole War, when Aaron Jernigan took advantage of the Armed Occupation Act of 1842. The law rewarded White homesteaders with one hundred and sixty acres of land in return for building a cabin within two miles of a military fort, tending to five acres of land for five years, and helping repel Seminole Indian attacks. Today, the site of Fort Gatlin is a suburban neighborhood much like the other neighborhoods surrounding downtown Orlando. As in cities nationwide, just as it was on the American frontier, these neighborhoods grew out of federal subsidies designed to encourage White homeownership.

Platted in 1911, Highland Grove, later called Colonialtown North, was marketed by developer H. Carl Dann as "a place where your dollars will multiply while you sleep." A 1925 addition placed more streets and homes atop the Hilson citrus grove immediately to the south, expanding the neighborhood's border to Colonial Drive. Throughout the 20s and 30s Dann's developments spread south of Colonial into a patchwork of subdivisions that would eventually form Colonialtown South.

The 1920s marked the beginning of systemic segregation in Orlando. "The city established a zoning commission in 1923 and unofficially designated separate areas for Black residences in 1924." The southern expansion of White housing that began around

Highland Grove would eventually encroach upon Jonestown, Orlando's first Black community, founded circa 1880 by the formerly enslaved. With the help of hundreds of thousands of dollars in federal aid for "slum clearance" and the construction of Whites-only public housing, city officials oversaw the forced removal of Jonestown's residents, who were pushed west of Division Avenue into the Callahan and Parramore/Holden neighborhoods, areas which the city re-zoned for industrial use despite the Black community residing there. In 1957 the construction of Interstate 4 created a massive physical barrier between Orlando's Black and White communities, and displaced much of the former. Construction of the East-West Expressway in 1974 further displaced "thousands of houses … as many as two hundred businesses [and] at least six-hundred renters lost their homes."

Today, Orlando's Colonialtown North neighborhood occupies a three-square-mile grid of mostly single-family homes containing about four thousand people, 73% of whom are White. Like most of Orlando's bungalow neighborhoods, it sits on the east side of downtown, east of Division Avenue, east of Interstate 4, on the border of the urban/suburban divide. In other words: at the scene of the crime. In 2016, Reveal news found Black applicants in Florida's Orlando-Kissimmee-Sanford metro area were twice as likely to be denied a conventional home mortgage than White applicants. Latinx applicants were 1.6 times as likely to be denied. As of 2020, despite the growing diversity of suburbia, individual suburban neighborhoods remain staunchly segregated, perpetuating racial and economic injustices.

Though the legacy of redlining, racist covenants, and White terror continues to reverberate in Orlando and nationwide, Florida's history of White boundary policing predates the founding of the United States. Prior to 1776, Spanish Florida was a haven

for free and self-emancipated Africans, and thus a problematic territory for British colonists. As a potential solution, the Georgia colony was created as an intentionally all-White territory to buffer Spanish attacks on the colonies and prevent enslaved Africans from fleeing to Florida.

After the American Revolution, the existence of Florida challenged the country's founding contradiction of being a nation that exhorted freedom while holding people in bondage. In 1819, the United States acquired Florida from Spain in part to expand its buffer against abolitionist revolutions in Mexico and Haiti. Though the Florida Purchase extended citizenship to every inhabitant of the new territory, the U.S. ignored this provision. Florida's first territorial legislature enacted strict slave codes and subsequent legislatures established a system of volunteer patrols to police the enslaved. The signing of the Indian Removal Act in 1830 effectively broke The Treaty of Moultrie Creek, reigniting the war with Seminoles who had since been pushed to the center of the state. In short: Florida's incorporation into the United States meant the expansion of slavery and the forced removal of the Seminole Indians.

Even before statehood, the U.S. military built forts throughout the Florida territory for the purpose of Indian removal. Just as Fort Gatlin became Orlando, the area around these forts would grow into modern cities, some of which have kept their original names, like Fort Myers and Fort Lauderdale. A string of forts that stretched across Central Florida from Tampa to Daytona today traces the path of Interstate 4. This uncanny overlay of interstate and forts is no coincidence, rather, it reveals the practice of exclusion and expropriation that is white supremacist settler colonialism to be the foundation of U.S. American infrastructure. In this sense, Florida's forts can be understood as the state's first suburbs.

(RE)SOURCES

— *Orlando: City of Dreams*, Joy Wallace Dickinson, Arcadia Publishing, 2003

— "Announcement to the People of Orlando and Florida," *Orlando Evening Star*, Jan. 6 1912

— "Orlando's Division Street: The history behind what became a symbol for segregation," Tana Mosier Porter, Orange County Regional History Center blog, July 7, 2020

— "This was Jonestown," Tana Mosier Porter, OCRHC blog, Aug. 13, 2020

— "Jonestown Negro Removal Planned in Project," *Orlando Morning Sentinel*, Feb. 24, 1939

— "Segregation and Desegregation in Parramore," Tana Mosier Porter, *The Florida Historical Quarterly*, Vol. 82, No. 3 (Winter 2004)

— "Modern-Day Redlining" map, Reveal News, apps.revealnews.org/redlining

— "Separate and Unequal: Persistent residential segregation is sustaining racial and economic injustice in the U.S." Brookings, Dec. 16, 2020

— *The Counter-Revolution of 1776: Slave Resistance and the Origin of the United States*, Gerald Horne, NYU Press, 2014

— "Slave Unrest in Florida," Ray Granade, *The Florida Historical Quarterly*, Vol. 55, No. 1 (July 1976)

— *Slavery in Florida: Territorial Days to Emancipation*, Larry Eugene Rivers, University Press of Florida, 2009

— *Black Seminoles: History of a Freedom-Seeking People*, Kenneth W. Porter, University Press of Florida, 2013

ABOUT THE AUTHOR

Ryan Rivas is the Publisher of Burrow Press and the Coordinator of MFA Publishing for Stetson University's MFA of the Americas creative writing program. A Macondo Writers Workshop Fellow, his writing has appeared in *The Believer, The Rumpus, Literary Hub, Necessary Fiction, Best American Nonrequired Reading 2012*, and elsewhere. Find more of his work at ryanrivas.net.

ACKNOWLEDGMENTS

Perpetual thanks: To Mike Wheaton for helping me discover this project and for giving it a great home at Autofocus. And to Amy Wheaton for the stunning cover art.

Profuse thanks: To Teresa Carmody and Jared Silvia for intellectually and creatively rigorous conversations. To early readers Nathan Holic and Mark Pursell. To my "good art friends": Ruth Aitken, Aisha Ahmad, Chad Anderson, Matt Emery, and Raj Reddy for supportive community and feedback. To Terri Witek, Cyriaco Lopes, and Urayoán Noel for encouraging this project along the way. To countless Orlando people including but not limited to Teege Braune, Hunter Choate, John King, and Jamie Poissant. To Noelia Irizarry-Roman, research associate at Orange County Regional History Center, for help finding inspiration in the archives. To the paintings of Ericka Sobrack for helping me re-vision my residential surroundings (a few of the photos in this book are directly influenced by her work). To the historians, scholars, and activists that informed the conceptual nature of this work. And of course to Chelsea Simmons for keeping me alive.

Scan for supplemental book content